The Library
of Tattoos
and Body
Piercings

A Cultural History of Body Piercing

Other titles in the Library of Tattoos and Body Piercings series:

A Cultural History of Tattoos

Tattoos, Body Piercings, and Art

Tattoos, Body Piercings, and Health

Tattoos, Body Piercings, and Teens

A Cultural History of Body Piercing

By Bonnie Szumski and Jill Karson

ReferencePoint
Press®

San Diego, CA

ReferencePoint
Press®

© 2014 ReferencePoint Press, Inc.
Printed in the United States

For more information, contact:
ReferencePoint Press, Inc.
PO Box 27779
San Diego, CA 92198
www.ReferencePointPress.com

LIBRARY OF CONGRESS CATALOGING-IN-PUBLICATION DATA

Szumski, Bonnie, 1958–
 A cultural history of body piercing / by Bonnie Szumski and Jill Karson.
 pages cm. -- (The library of tattoos and body piercings)
 Includes bibliographical references and index.
 ISBN-13: 978-1-60152-558-1 (hardback)
 ISBN-10: 1-60152-558-3 (hardback)
 1. Body piercing--History. I. Title.
 GN419.25.S98 2013
 391.7--dc23
 2013009273

Contents

A Little Rebellion or a Sign of Deep Distress?

Piercing is becoming increasingly popular, especially among people aged eighteen to twenty-nine. Though statistics are hard to find, a 2006 survey completed at Northwestern University found that women accounted for almost three-fourths of people with body piercings (not including earlobes), while a third of those surveyed got their first piercing when they were under age eighteen. Since 2006, however, piercing has grown in popularity, so this information represents a smaller population than is found today.

Tattoo parlors report an uptick in piercings of teenagers (most of whom must have the permission of a parent to be legally pierced). Loren Gooden, a piercing artist at Thrash's Tattoo in Rapid City, South Dakota, claims, "It has really picked up in the last three years."[1] Moe Delfani, owner of a tattoo and piercing salon in San Francisco, says that he does about four thousand belly piercings a month, with 85 percent of them girls in their teens and twenties.

Expressions of Individuality and Rebellion

Some experts attribute the rise in body art, including piercing, among the young to physiological and psychological changes that take place in these years. Teens, for example, are typically self-centered, believing that they and their problems are unique. This belief in uniqueness is what psychologist David Elkind termed the personal fable. Elkind noted that

the fable allows teens to believe that they will not suffer consequences of risk-taking behavior, for example, because nothing bad can happen to them. Some psychologists see the desire for piercings among ever-younger individuals as part of this thinking. With no thoughts of what the future might bring, including jobs and personal status, teens want a piercing now and see it as a stamp of personal style.

In addition to being a way for teens to express their individuality, body piercing can also serve as a personal ritual of rebellion. Eighteen-year-old Charlotte, for example, claims that her piercings and tattoos are just part of the rock clique she wants to belong to. "This is about me, and what I want," she says. "Why should [mom] dictate to me, now I am 18? I am not willing to change who I am just to make other people happy. I know I am the anomaly in my family—my sisters and I weren't exactly brought up to love tattoos, piercings, and heavy rock music. This is something I fell into completely by accident."[2] Charlotte's explanation seems to echo Elkind's teen personal fable theory—that the changes she makes to her body are no one else's business but her own.

Michelle Robertson got her belly-button ring as soon as she turned eighteen, as a rite of passage to adulthood. She explains:

> For me, getting a belly button piercing exemplifies this confusing time of semi-adulthood. Piercings are more than silver baubles that protrude from the body's crevices—they are loaded fashion statements that encompass profound psychological connotations. I pierced my belly button thinking it was a physical expression of my entrance into adulthood, the ability to make decisions for myself. But when my belly button got infected, I knew I had botched that first test of maturity because my decision-making skills proved faulty.[3]

Michelle's reflections run deeper than Charlotte's; she ponders how her decision resulted in an infection and her need to deal with a health issue on top of her spontaneous piercing decision.

Did You Know?

Although the body of research is not large, a small number of studies on the general adolescent population suggest that tattoos and body piercing are associated with low self-esteem.

Dangerous Behaviors

This impulsivity has linked some pierced and tattooed teens to other, more dangerous behaviors. A long-term study of about one thousand teens completed by Keren Skegg and other researchers at the Department of Psychological Medicine at the University of Otago School of

Body piercings, especially multiple piercings, have become popular among teens and young adults. Piercings are sometimes viewed as an expression of individuality but other times as a sign of rebellion or even of emotional difficulty.

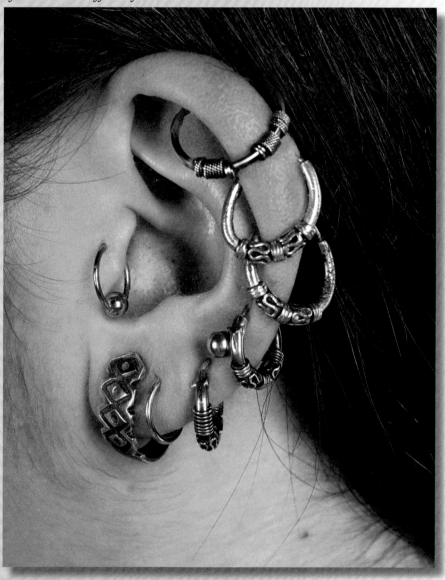

Medicine in Dunedin, New Zealand, studied a group of individuals from their teens through their early twenties who were tattooed and pierced. The study focused on dangerous and aberrant behaviors such as criminal actions, drug use, and sexual promiscuity. Participants were interviewed at eighteen, twenty-one, and twenty-six years old. According to the study:

> In total, 183 participants (9% of the men and 29% of the women) had piercings at a site other than the earlobes. People who lived outside New Zealand or who were of Maori descent were more likely to be pierced, but unemployment and low occupational status were not significantly related to piercing. Women who were pierced, compared with those without piercings, were more likely to have personality traits of low constraint or high negative emotionality. Women with piercings were also more likely to report having had, during the previous year, five or more heterosexual partners. . . . In this population, body piercing in women was associated with sexual behavior. Having multiple heterosexual partners or any same-sex partner was very rare among women without piercings.[4]

A study in Switzerland in 2007 found similar results with teen girls who had multiple piercings. The study concluded that multiple piercings were associated with poor academic performance, sexual promiscuity, eating disorders, and illegal drug use.

So, in some individuals, tattoos and piercings at an early age are indicators of a troubled teen who may be seeking out dangerous activities as part of escalating behavior problems. Cap, for example, pierced his own ears at fourteen and went on to pierce his nipples, septum, tongue, and genitalia. As a teenager Cap had trouble at home, leaving at age fourteen. Seeking to find a supportive group of friends, Cap became part of the Southern California biking scene, in which he also heavily indulged in drinking and drugs before age twenty-five. Cap also became heavily tattooed. Today, in his fifties, he is a reformed alcoholic and a successful

Did You Know?

More and more in the contemporary piercing community, body jewelry is being made from organic materials such as wood, bone, stone, or horn, as opposed to metal.

tattoo artist who owns his own shop. Cap recalls that he was caught up in the "erotic stimulation of the piercings"[5] and also admits that he actively sought out risky behaviors.

Whether piercings are merely a way for teens to play with being a little dangerous or whether piercings are a predictor of true psychological crying out clearly depends on the individual. In either case teenagers are seeking at younger and younger ages to make piercing a part of their look.

Body Piercing Loses Its Stigma

Though the history of piercing is spotty at best, people from all over the world have been practicing the art since antiquity. In India's ancient religious texts, the Vedas, which date from 1500 BC, the goddess Lakshmi is depicted wearing earlobe and nose piercings, which indicates the art was known to the ancient Indians. Ötzi the Iceman, the fifty-three-hundred-year-old mummy found in the Austrian Alps, was found to have earlobe piercings. When the tomb of the Ukok princess, which dates from 400 BC to 300 BC, was unearthed on the border of China and Russia in the 1990s, gold earrings for use in pierced ears were found near the body. Evidence of piercing has also been found in ancient Greece and Rome, as well as throughout the ancient cultures of Mesoamerica and South America. Clearly, the desire to use piercing for adornment of the body, religious purposes, tribal affiliation, or sexual pleasure has always been and continues to be a significant part of the human experience.

Why Do People Do It?

Body piercing is one of the oldest human rituals, practiced for thousands of years in almost every culture of the world. On the question of why our ancestors used piercings or other forms of body modifications such as tattoos, Jean-Chris Miller, editorial director of Art & Ink Enterprises, writes:

> Maybe they marked themselves for defense; a person with big black stripes on his face or a boar's tooth through his nose could frighten an attacker off just by his appearance. They may have

used tattoos and scarification as an early form of magic; a permanent symbol of the warm sun, for example, may have been thought to help stave off the effects of a cold, dark night. They could have shown spiritual devotion by "sacrificing" their flesh to the gods or made permanent marks that signified tribal affiliation. It could have been a way of proving they were brave and courageous warriors strong enough to stand the pain of ancient body-art practices (a true test of stamina!). Or it's possible they were just trying to improve their looks.

At some point in time, all of the above were reasons people got tattoos, piercings, or other modifications; Nothing has changed in thousands of years, except the symbols themselves—and (thankfully) improved methods for doing the work![6]

While the reasons for ancient piercing can only be guessed at, it seems likely that they are the same reasons offered by people today. Ear piercing has become so commonplace as to go virtually unnoticed, while other forms of piercing—through the nose, belly button, nipples, and tongue, to name a few—may have their roots in more personal longings. According to Miller, "Because we have few rites and rituals that mark life transitions or prove our devotion to a particular group or idea, body art often fills that void. Whether to signal a life passage or to enforce a belief, the ritual and permanency of body art fulfills some basic need we have as sentient [feeling] beings."[7]

Piercing's Historic Origins

Piercing's origins are ancient. At the University of Pennsylvania's Museum of Archaeology and Anthropology, a four-thousand-year-old figurine from Iran is adorned with multiple ear piercings. Also on display are earplugs, large cylindrical ornaments that are inserted into piercings, that came from Guatemala and date back to AD 1500.

In fact, ear piercing is one of the most common body modifications in the world. Both men and wom-

Did You Know?

The book *Modern Primitives*, which popularized neotribal tattoos and piercings, was banned in England in 1989. Although the ban was short-lived, it helped make the book famous.

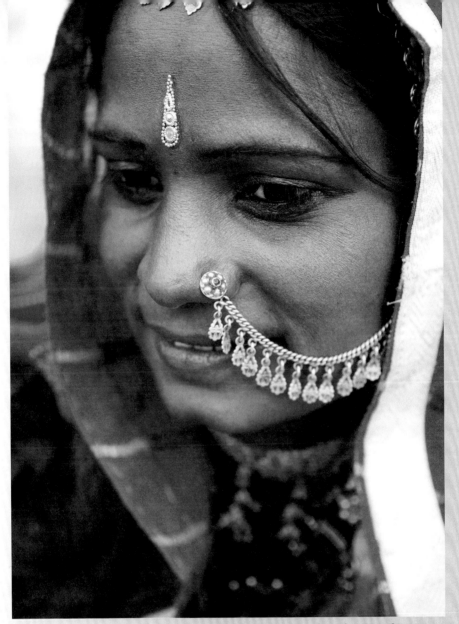

Nose piercing among women in India is a tradition that dates to the 1500s but the practice is still common in modern India. Women who obtain piercings often wear a stud in the left nostril, which then might be joined to the ear with a decorative chain.

en engaged in a variety of ear piercing in ancient Egypt. Jewelry from that time includes studs, earplugs, hoops, and lotus flower earrings.

The ancients pierced not only their ears, but other body parts as well. A statue of Pharaoh Akhenaten from 1400 BC shows a navel piercing that many believe was once adorned with gold jewelry. Some historians

Piercing Pioneer Elayne Angel

Elayne Angel has been a professional piercer for more than twenty years and is on the board of directors for the Association of Professional Piercers. In her book *The Piercing Bible*, Angel recounts her early foray into piercing:

> Way back in 1972, I shocked my poor mother when she opened the bathroom door and caught me in the act of poking another hole through my already-pierced ear. I assured her, "Mom, other people are going to do this, too. I just know it!" Naturally she didn't believe me at the time; she and my father thought I was an inexplicably unusual girl.
>
> Being a piercer wasn't a common vocation when I started working at a small business called Gauntlet in the 1980s. There was only one piercing specialty studio in the United States, and I was its manager. . . . My dismayed parents visibly blanched when they learned about my career move.
>
> More than thirty years after that first incident in the bathroom, my parents were amazed to find that the "freaky piercing stuff" I'd experimented with in my youth has actually become a part of our contemporary culture.

Elayne Angel, *The Piercing Bible: The Definitive Guide to Safe Body Piercing*. Berkeley, CA: Crossing, 2009, p. ix.

believe that during the first century AD, nipple piercing was practiced among a class of Roman military officers known as centurions. Such piercing could have signified the centurions' superior masculinity, status, or bravery. One source of uncertain authenticity claims that these nipple piercings had a more mundane use—to fasten their capes in place.

In first-century-AD Mexico, members of the Mayan, Olmec, and Aztec civilizations had a rich tradition of piercing, including piercing their ears, nose, lips, tongue, navel, and genitalia for aesthetic and spiritual reasons. Mayan kings and noblemen bored holes in their front teeth to insert precious metals, particularly jade or obsidian. The wealthy also elongated their earlobes by inserting large disks of gold, silver, or wood into them. This practice made the Spanish dub them *orejones*, or "big ears."

Nose piercing in India dates from the sixteenth century but is still common today. Indian women typically wear a stud or ring in the left nostril, sometimes joining the piercing to the ear with a chain. The left nostril is used because in traditional, or Ayurveda, medicine, the left nostril is associated with the female reproductive organs. Thus, the piercing is supposed to make childbirth easier and lessen the pain of periods.

Piercing Spreads to the West

Piercing took longer to penetrate the cultures of the West. Before the nineteenth century, piercing in the West was primarily relegated to sailors and sideshow entertainers. Sailors, who had exposure to other parts of the world, were especially prone to ear piercing and tattoos. A gold earring, many sailors believed, would pay for their burial if they were washed ashore after a shipwreck.

For the otherwise modest high-society British women of the nineteenth century, piercing the chest had a small but significant following. Piercing the nipples, coupled with a plunging neckline, was a daring way to show independence. Ear piercing became popular as well and spread from Europe to the United States. In Britain a piercing of the male genitalia called the Prince Albert was popular among some men who wore tight, fashionable trousers.

Though some high-society Britons flirted with piercing, through the early part of the twentieth century, piercing (except ear piercing) remained almost unheard of in American culture. Early American settlers believed

Did You Know?

The shamans and other religious figures of the Haida, Kwakiutul, and Tlinglit tribes of the American northwest pierced their tongues to draw blood and heighten consciousness, believing this would foster communication with the gods.

such body modifications were evil and demonic, and they interpreted Biblical scripture to prove that God disapproved of such adornments. Especially convincing to the Puritanical mind were passages in the Old Testament such as Leviticus 19:28, which states, "You shall not make any cuts on your body for the dead or tattoo yourselves: I am the Lord."[8] Or 1 Corinthians 6:19, which states, "Do you not know that your body is a temple of the Holy Spirit within you, whom you have from God? You are not your own."[9] Americans who considered themselves god-fearing, law-abiding citizens took such proscriptions seriously.

Early American prejudices were surely reinforced when they encountered Native American tribes, considered by many to be ungodly savages. Many tribes practiced piercing, especially piercing of the ears and septum. In fact, the name of the Washington State tribe Nez Percé was given to them by French fur traders. Translated into English, *Nez Percé* means "nose piercing."

Piercing Goes Mainstream

Though still underground and more the purview of rebels and society's fringe, piercing began to gain a small but significant following in the 1970s. One of the people considered a foundational pioneer in piercing is Fakir Musafar, who coined the term *modern primitives* in the 1970s for people who, like himself, enjoyed piercing their bodies for pain and adornment. Inspired by photographs of native peoples in *National Geographic* magazine, Musafar (born Roland Loomis in 1930) began experimenting with piercing in the 1950s, though he did not become widely known for his fascination with his own and others' self-mutilations through piercings until the 1970s. Musafar linked piercing both with exploring spirituality through pain (as many Native American cultures had) as well with altering the body. He still teaches workshops in the art and lore of piercing. In an interview that appeared in the book *Modern Primitives* Musafar explained his view of how pierc-

ing, and the effect it has on human psychology, is deeply rooted in primitive culture:

> Today, a whole part of life seems to be missing for people in modern cultures. Alienation is running amok. There are huge signs and symptoms of massive alienation. Whole groups of people, socially, are alienated. They cannot get closer or in touch with anything, including themselves. Why? What's going on here? Well, there have got to be some remedies and they're going to come from some very strange places.
>
> It all comes down to: *it's your body, play with it*. For a long time Western culture has dictated: don't [alter] . . . the body; it's the temple of God. But finally people are starting to see things in a different way.
>
> Times have changed, people have changed. The way I see it is: people *need* these rituals so desperately; that's why piercings and tattooing have blossomed. People need physical ritual, tribalism—they've got to have it, one way or another. [10]

Musafar believed that piercing could lead to a sort of ecstatic state, just as primitive people had when they practiced their rites and rituals. He believed that much of this spirituality was experienced through performing rituals during the piercing session. He talked about one man who used nipple piercing as a way to access and let go of the pent-up pain that he had experienced as a gay man who had been rejected by friends and family. The piercing session involved burning incense, playing music, and encouraging the man to relate the experience of the piercing to releasing the negative pent-up energy he had stored.

It is not surprising that piercing gained more of a following during a time when self-expression and rebellion became more radicalized during the 1960s and 1970s. Piercing started to become popular among hippies on the West Coast during this time, especially among those who had traveled to India, where septum piercing was common. Members of the punk movement, especially in Britain, used piercing as one more form of angry rebellion, changing their appearance to become frightening and off-putting to the mainstream.

Two major pioneers who helped bring piercing into the mainstream were also part of the homosexual community. As Victoria L. Pitts writes:

> Body modification's queer history has played a significant role in the rise of the body art movement. Queer men and women were pioneers in the development of eroticized, ritualized body art, and were the early enthusiasts of modern primitivism. Since the 1960s and 1970s, when radical gays and lesbians embraced tattoos and gay men used body piercing, body art has been a significant part of gay subcultural style.[11]

A Gay Subculture of Piercing

Jim Ward and Doug Malloy were instrumental in organizing a subculture of men who enjoyed piercing and wanted to share their experiences. Malloy began a social club for gay men interested in piercing and also gave Ward the seed money to begin a piercing business. Ward operated a body piercing studio out of his home in West Hollywood in the mid-1970s. He then opened a storefront called The Gauntlet, the first body piercing studio in the United States. Ward originally catered to some members of the homosexual community. As piercing pioneer Elayne Angel writes, this community "used piercing as a profound means for expressing their alternative sexuality."[12]

Ward, Musafar, and Malloy also began the world's first professional publication specifically geared to the art of piercing. Called *Piercing Fans International Quarterly*, the periodical began in 1977 and stopped with the closing of The Gauntlet in 1998. This period coincided with the gaining popularity and acceptance of piercing. After The Gauntlet opened its doors in the early 1970s, piercings in parts of the body other than the ear started to become more common. As one observer noted: "The Gauntlet, founded in Los Angeles in 1975 . . . now has three shops around the country that are about as controversial as Elizabeth Arden salons. Rumbling through the biker culture and punk, piercing gradually shed its outlaw image and was mass marketed to the impressionable by music videos, rock stars and models."[13]

Modern Primitives

Another landmark in the history of piercing was the 1989 publication of the book *Modern Primitives* by V. Vale and Andrea Juno. The book

Doug Malloy—Piercing's Mythmaker?

Many people credit piercing pioneer Doug Malloy with many of the myths that surround piercings' ancient origins. In his book, titled *Adventures of a Piercing Freak*, Malloy described his many travels and how they led to understanding where and how piercing had been practiced. Fellow piercing pioneer Jim Ward had this to say about Malloy's book:

> The impact the "Piercing Brief" has had is phenomenal. It was widely distributed and reprinted and contained many of the colorful myths that persist and, to some extent have been widely accepted as fact. There has never been any proof to substantiate, among other things that:
>
> Roman Centurions wore nipple rings to which they attached short capes.
>
> Navel piercings were a sign of royalty in ancient Egypt. . . .
>
> Arab boys had the side of their scrotums pierced at puberty. . . .
>
> The evidence on which Doug based his Roman Centurions claim was a Baroque statue he'd seen in Versailles. He showed me a photograph. I pointed out to him that Roman military men frequently wore metal breastplates sometimes sculpted to resemble a muscular male chest. The rings with cape attached were in the breastplate, not the man. Doug paused for a moment to ponder my observation, then replied, "Well, it makes a good story anyway."

Since much of piercing's history has been lost, it seems that Malloy supplied such a need for information that it was irresistible to fill in the gaps.

Jim Ward, "Who Was Doug Malloy? Part I," BME.com, March 15, 2004. http://news.bme.com.

was the first attempt to systematically document the modern interest in piercing and scarification and to explain and popularize the neotribalist and modern primitive movement. These terms describe people who use piercing and tattooing as a way to bring ancient practices into their modern lives. By using modern surgical and cosmetic techniques to alter the body, such as implanting metal spikes under the skin to project through the head, modern primitives are asserting that piercing is remaking their body into a personal vision.

The movement defines itself as appealing to those who struggle with a perceived loss of identity in an increasingly overpopulated, globalized modern world. For these people the practices of more primitive tribal

A body piercing artist pierces the nipple of a male client. Nipple piercings gained in popularity immediately after the infamous 2004 Super Bowl halftime show during which singer Janet Jackson's right breast and nipple piercing were accidentally exposed on national television.

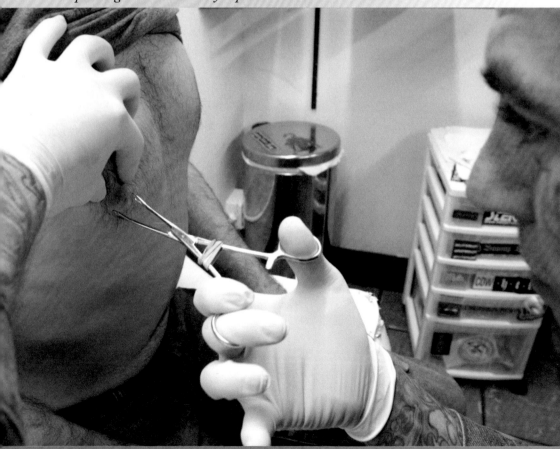

cultures infuse meaning and perhaps a sense of power into their lives. Musafar writes that these practices are also a rejection of mainstream Western attitudes about the body: "We had all rejected the Western cultural biases about ownership and use of the body. We believed that our body belonged to us . . . [not to] a father, mother, or spouse; or to the state or its monarch, ruler or dictator; or to social institutions of the military, educational, correctional, or medical establishment."[14]

Celebrities Increase Piercing's Popularity

Rock stars and Hollywood starlets were, and are, largely responsible for the mainstreaming of unusual body piercings. Many credit the gaining popularity of belly piercing to a 1993 music video by the rock band Aerosmith. In it, the popular then-teenage actress Alicia Silverstone appears to be undergoing a belly piercing. (In reality, the actress was underage and a body double appeared in her place). While the video encouraged hundreds of young women to seek out the services of a body piercer, there were still few to be found. Many appeared at the doors of tattoo parlors, thinking that such alternative places would also be likely to have piercing services. Few did. However, it did not take long for those establishments to take on the task, and the link between the two remains today.

Celebrity use of body piercings continues to increase its popularity. During the 2004 Super Bowl halftime show, for example, Janet Jackson performed a medley of her singles, culminating in a performance with Justin Timberlake of the song "Rock Your Body." As Timberlake sang, he tore open her top, accidentally exposing her right breast and her nipple piercing. While much of the public was appalled at the display, it spurred hundreds of young women to go out and have their nipples pierced. Jackson's subsequent interviews about her piercings brought attention to her more unusual piercings, including her genitalia. In an interview with Vibe Vixen, Jackson explained that "we used to have piercing parties, and we'd all get something done. All my friends would come to the beach and Rob, the body piercer . . . would pierce all of us. Getting my [nasal] septum pierced sounded like putting a knife through

leather, so that was the ugly part of it. . . . Others, you inhale and you exhale and it's done."[15]

Other Hollywood actresses and rock personalities have been just as open about their piercings. Britney Spears and Keira Knightly have regularly exposed their belly-button rings, while Christina Aguilera and the avant garde Lady Gaga have publicly spoken about their genitalia piercings. Largely due to the increased exposure and acceptance, body piercing is one of the most common forms of body modification.

A Dark Side?

At the same time, some worry that there is a darker side to the practice. As piercing becomes more mainstream, extreme forms becoming more prevalent. According to Rufus C. Camphausen, author of *Return of the Tribal: A Celebration of Body Adornment*:

> Some people seem to have gotten involved in a progressive spiral of being the most outrageous of all. Once a single facial piercing, on lip or eyebrow, was enough to catch everyone's attention and the admiration of some. Now we can read of more and more brandings, scarifications, and such extreme forms as metal nails and plates inserted into the lips and even horns into the skull. To some of these extremists, neither the enhancement of beauty nor learning to deal with pain seems important; rather it's being radical that is the point.[16]

The most disturbing cases are of people who have so transformed their appearances that they have tried to make themselves look like the devil or like animals such as cats or lizards. While piercings only make up a part of such transformations, they are an integral part of the overall effect. One individual, Maria Jose Cristerna, has hundreds of tattoos, titanium horns embedded in her skull, and piercings all over her body. Cristerna has said in interviews that she believes the extreme changes in her appearance have allowed her to gain control and free herself from the trauma of an abusive past.

Psychologists who have studied piercings have noticed the link between some of these more extreme piercings and a traumatic past. Piercers who describe having lived through sexual abuse, physical abuse, and the resulting depression and feelings of humiliation and revenge argue that piercing helps them overcome these feelings. Psychologists worry that such expressions, however, may continue the pattern of self-hatred and self-harm, rather than promote feelings of empowerment and freedom.

The trend of extreme piercing among teenagers has caused some to wonder whether such adornment could be just one more form of

Maria Jose Cristerna (pictured) has piercings all over her body, hundreds of tattoos, titanium horns embedded in her skull, and dental fangs. She describes the extreme changes in her appearance as a way to free herself from an abusive past.

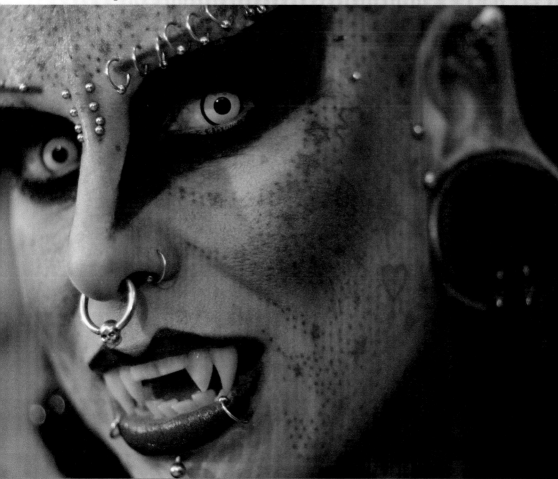

self-mutilation, like cutting. No one argues that addictive behavior such as cutting, which some teens use to lessen psychological pain, is healthy. Yet it is difficult to tell, as psychologist Lawrence Rubin speculates, whether piercings and tattoos go as far as cutting:

> Might there be alternate, less pathological explanations for this tsunami of seeming self-desecration? At a most basic and benign level, perhaps tattooing and piercing are simply forms of self-expression, a means of marking ourselves in a society that fosters, both wittingly and unwittingly, anomie and anonymity. Perhaps, as postmodernists might argue, this self-marking is a means of asserting mastery and control over our bodies, and anchoring ourselves, quite literally during a time of life when the only constant is change. Maybe it is not self-mutilation, but rather self enhancement and adornment, a means of saying "I am" in a way that is heard . . . body bling! . . . For some, it may simply be the rush of adrenaline that accompanies a self-chosen and self-controlled moment of physical pain.[17]

Whether piercings express dark and addictive tendencies or celebratory moments of control over the body remains a question of personal opinion and reflection.

Chapter Two

Piercing as a Way to Forge Identity

The urge to alter one's body through physical change, whether with tattoos, piercing, cosmetic surgery, or other alterations, occurs in cultures all over the world. The reasons for these alterations can range from the simple belief that such alterations improve one's appearance, to more comprehensive reasons, including expressions of individuality or identifying with a group. As Chris Rainier argues in the book *Ancient Marks: The Sacred Origins of Tattoos and Body Marking*, "Millenia after the dawn of man's awakening, we continue to etch the geography of our bodies as we have always marked the landscape of the earth. In creating these sacred forms, we forge a critical element of human existence—our identity."[18]

Marking and decorating the body seems, for many people, a way to express their own artistic sense. In the foreword to Rainier's book, the anthropologist Wade Davis compares the body to a canvas, just like any other:

> If the skin of the average human body were laid out as flat as a map, a sheet of parchment, it would cover more than twenty square feet. Had Leonardo da Vinci chosen the human form as his canvas, he would have had a work surface four times the size of the Mona Lisa. Fully engaged in the palpable excitement of the Renaissance, da Vinci remained focused on other possibilities of expression. But throughout history and for the vast majority of the artists of the world, the body has always been the template of the spirit, the palette from which all dreams and possibilities may be realized.[19]

For some people, then, their own body is an available canvas all their own that they can decide to personalize and control.

Symbols of Beauty

Many cultures view piercing as a permanent expression of beauty and sexuality. As Jean-Chris Miller writes: "Body art is . . . a way of recognizing our physical bodies, celebrating our corporeal selves with marks that are aesthetically pleasing. . . . That glint of metal jewelry against the skin is an exotic and erotic compliment."[20]

Many modern piercers use as their inspiration the native tribes of the world who have always used and continue to use piercing for a variety of reasons. The African Masai and Fulani tribes, for example, pierce their ear cartilage as a way to show off their beauty and their status. Other African tribes implant discs and plates to transform their lips and noses, such as the Mursi tribal women in Southern Ethiopia, who elongate their lips with plates. In the rain forests of Brazil, the Zo'e tribal members wear a wooden plug piercing the bottom lip called a poturu, which they find beautiful. Some native tribes, especially those in New Guinea and Australia, pierce their nasal septums to gain magical powers. They believe that the piercing breaks the barriers between the sense of smell and the sense of sight, allowing for supernatural vision. Such piercings quickly identify people as being a member of a particular tribal group, one of a host of reasons still used today by modern piercers.

Forging Identity in the Modern World

Unlike many native peoples, today in the Western world many people don piercings to identify themselves as being outside the norm of society.

A Mursi woman with a large lip-plate is photographed in Ethiopia in 2010. The lip-plate is an expression of adulthood, reproductive potential, and the bond between the woman and the society in which she lives.

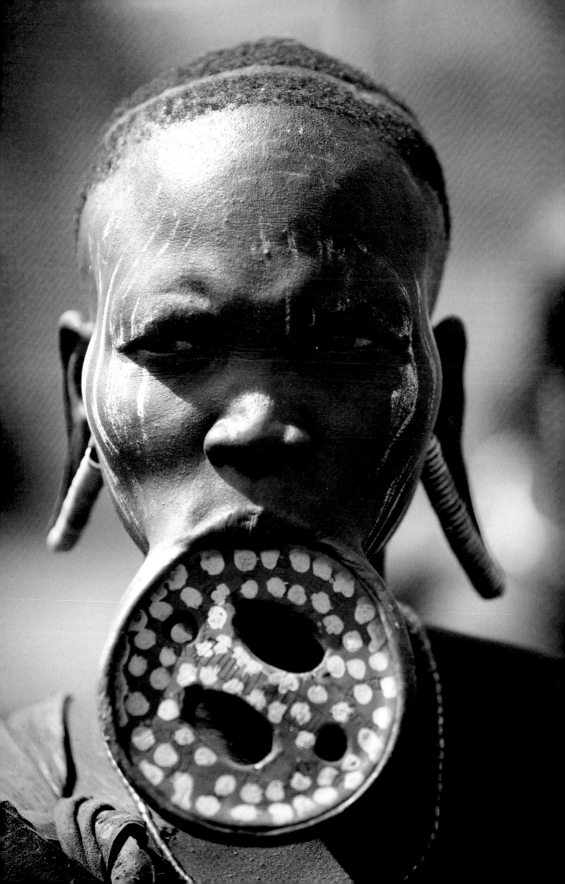

In a world where almost any form of dress is acceptable, piercing can still be thought of as a bit outside the norm. According to Miller:

> Modifying your body to what *you* want it to look like is a very strong statement. You're asserting control over your own physical being in a society that increasingly regulates what you can and can't do with it. From the moment you're born, you're bombarded with images of what your society wants you to look like. In the Western world, those images are really very plain—there's very little variety in the way we look. When you take the initiative to decorate yourself in a nontraditional manner, you're taking back power from a culture that doesn't want you to stand out or be different. You're also rejecting the conventional rules of decorum. It's *your* body and you can do what you like with it.[21]

Rebellion against the social norm is commonly cited as a reason for getting piercings. This was the case with those who identified with the punk rock movement of the 1970s and 1980s. In the late 1970s in Britain, unemployment was the harsh norm for many working-class people. Punks expressed their feelings of despair and hopelessness during this time by altering their appearance to shock and repel, with artificial hair colors and harsh, asymmetrical haircuts, ripped and bedraggled secondhand clothes, and tattoos and piercings. Not looking attractive was important to punks; they wanted their appearance to make outsiders cringe. Punks prided themselves on their homemade artwork, such as safety pins shoved through the flesh of their face, ears, and nose. According to John Michael Byrne in an essay titled "Tattooing and Piercing in the Punk Subculture":

> The most potent signifier of difference [was] the punk style of piercing such as razor blades or safety pins through the ears, nose or mouth. . . . [Author Daniel] Wojcik notes that piercings invoke "particularly powerful symbolic connotations (deviance, pain, masochism, self-destruction)" and that these connotations meant that the piercing "seemed to disturb non-punks more than all the other styles—hair, leather jackets, clothing and tattoos—combined."[22]

Although their piercings were shocking, punks were actually responsible for making piercing more acceptable. And even though the more

Motivations for Body Modification

In a 2008 study at the University of Zurich, lead researcher Rhea Kalin reviewed existing literature on the topic of piercing and other forms of body modification and also conducted an online survey of students. Kalin identified the following motivations for modifying the body:

To be special or unique

To emphasize one's individuality

To have new and extreme experiences that push the limits

As a symbol of protest or rebellion

As a sign of group membership

To mark a phase in life

Sexual motives

Religious or spiritual motives

popular version never extended to sticking safety pins in the face, more people did seek out professional piercings of eyebrows, tongues, and other facial parts.

A similar sense of rebellion permeates the views of many who adorn themselves with piercings. For such people, body art can immediately help to identify them as people who push the boundaries of society or are unwilling to conform. As explained in the book *Modern Primitives*:

By failing to adhere to the rules of presentation of society, or by deliberately rejecting the decorative norms of the majority or dominant culture, an individual can demonstrate a rejection of conventional values merely by changing his or her outward

appearance. At the same time, by altering his or her body in a permanent way, a person can express a lasting allegiance to his chosen group, rather than risking the label of merely "going through a rebellious phase."[23]

Piercings can be hidden or completely removed in situations where one must conform, such as at work. This makes them particularly suitable for those who want to express rebellion while still claiming to adhere to social norms. This is true of the experience of one woman described in Miller's book:

> In school, [Kai] was a Girl Scout. She tutored children with learning disabilities on the weekends and graduated from high school with high honors. In college, she excelled and upon graduation landed a high-profile job in the financial world. If you saw her on the street, she would look like any corporate type, in conservative clothes and sensible shoes. But Kai has a secret. Under her navy-blue suit she sports many sexy piercings. She says she enjoys the metal in her body . . . because it's a way to express her wild side while protecting her professional image.[24]

Teens and Piercing

Just like the punks, many who undergo piercing are in late adolescence or early adulthood—a time of forging personal identity and trying to shock or appall the adults in their lives whom they may despise for their conformity to social norms. In her book, *Body Piercing and Identity Construction*, author Lisiunia A. Romanienko writes, "Public piercings are extremely effective in symbolically communicating defiance of conventional power and authority, facilitating the identification of like-minded others, and perhaps most expeditiously, alienating conventional members of society."[25]

One high school student recounts how she got a piercing to rebel against her strict Catholic upbringing:

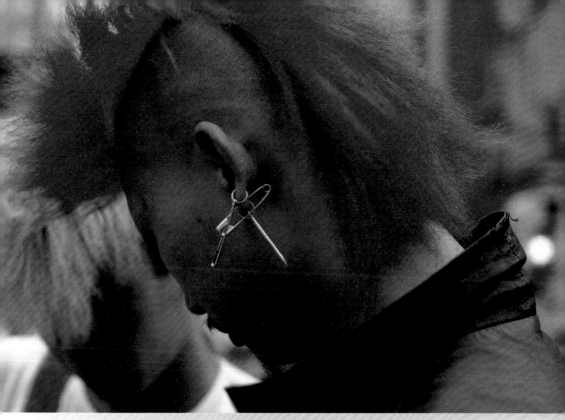

A Japanese punk in the 1980s sports a red Mohawk and safety pins in his ear. Punks turned to body piercing and unusual hair styles to express feelings of despair and hopelessness and to shock and repel.

I pierced my lip my junior year of high school myself. It's a weird thing. I've never even known other people did that kind of stuff. . . . I was like "wow, it looks so good," and it freaked everyone out which was kind of cool. I got [rejected] . . . at school because I went to Catholic school and we had to wear uniforms and they gave me lots of [crap] for it. I was the only person who had enough balls to actually wear the jewelry in school.[26]

High school students frequently cite the need to use the physical expression of body piercing as a way to signify their internal emotional and mental rebellion. Most such teenagers already have a hard time fitting in to conventional society, and tattoos and piercings merely reflect this sense of alienation. Therapist LuAnn Pierce notes that in such teenagers,

The tendency toward creativity and artistic expression is often misunderstood and these kids are too frequently labeled as abnormal.

. . . Their efforts to fit into [traditional] groups often lead to rejection, and most learned that in elementary school. Their behavior, or misbehavior, is usually their way of trying to get their needs met. The need for belonging, acceptance, and esteem will come from somewhere, and if the mainstream does not offer it some other group will.[27]

In some teenagers, then, piercings may signify a deeper and more profound longing and pain than that experienced in normal adolescence. In fact, in some cases therapists see multiple piercings as an

The Mayan Quest for Beauty

Mayan scholar Wes Christensen describes some of the rituals, including extreme piercings, the ancient Mayans performed in their quest for beauty:

> In their quest for the perfect facial profile, head deformation was a routine practice, begun in infancy, the forehead shaped in wooden molds into an admired, continuous arc extending back from the (often artificially enlarged) bridge of the nose. Male facial hair was stunted by scalding compresses, then plucked out—like female eyebrows. Bodies were painted to indicate status, occupation, as an insect repellant, and for pleasure. Tattoos were acquired over much of the face and body by both men and women. Lips, noses, and earlobes were pierced and decorated with as expensive jewelry as the wearer could afford. The openings in the ears were gradually stretched out to an astonishing degree, judging from excavated examples of jade "ear flares" found in tombs.

Quoted in V. Vale and Andrea Juno, *Modern Primitives: An Investigation of Contemporary Adornment & Ritual.* San Francisco: Re/Search, 1989, pp. 80–81.

indicator of a youth who is at risk. In their study on teens and body art, social workers Marthe Deschesnes, Philippe Fines, and Stephanie Demers write:

> Given the strong link between body modification and "externalised risk behaviours" in high school students, tattooing and body piercing may serve as clinical markers that can provide health professionals with additional warning signs. . . . Tattooed or pierced teenagers require careful evaluation in order to identify those who may be involved in activities that could potentially hinder their security and development.[28]

Deschesnes, Fines, and Demers found that a significant portion of pierced and tattooed teenagers were also involved in drugs, illegal activities, and truancy. Yet for many other teenagers, a pierced eyebrow, extra ear piercing, or belly-button ring is a merely way to experience a bit of rebellion and is not an expression of deeper mental health issues.

Women and Piercings

Though piercings among women were fairly uncommon even ten years ago, many more women are engaging in piercing and are identifying with body art in a significantly different way than men. According to Elayne Angel, "Women, in particular, are bombarded by the media's unrealistic notions of beauty, which deeply affect self-esteem and body image. They may turn to piercing or other forms of body art to help them embrace a positive attitude about themselves. While there is no unanimous consensus about whether body jewelry enhances appearance, aesthetics is a widespread motivating factor for piercing."[29]

Using piercing to beautify while at the same time shake up people's perceptions, while not unique to women, is a significant factor. One Asian woman explained she uses her piercings to overcome a racial stereotype she felt many people pegged her with: "I have a somewhat flat face, and I feel the piercings give it the outline I would otherwise have to achieve through makeup every single morning. Also, people

Did You Know?

Among the Bedouins of the Middle East, a husband gives his wife a nose ring at their wedding. The size of the ring indicates the wealth of the family.

have a certain image of an Asian girl: the ever-smiling submissive and fragile cherry blossom princess. I think I had to do something to destroy that image, to make it visible that that isn't me."[30]

The idea that women who have piercings are rebellious and use the piercings as a way to express their individuality and nonconformity is backed up by scientific studies. In a study of women at the University of Otago School of Medicine in New Zealand, women who had piercings were more likely to be promiscuous, impulsive, and sensation seeking. They also admitted to being more prone to anxiety and anger and were more likely to be unmarried.

One popular image of a woman on the outskirts of society who uses her tattoos and piercings to redefine herself is the heroine of the movie *The Girl with the Dragon Tattoo*, Lisbeth Salander, based on the novels of Stieg Larsson. In the film Salander, clearly an outsider, is brutally raped. Yet she manages through her ingenuity to gain not only revenge, but also complete dominance over her attacker. Her multiple tattoos and piercings mark her as a powerful maker of her own destiny who cares little about impressing society as a whole. Salander echoes the image of what many women with piercings claim to have successfully managed—regaining their dignity and reclaiming their self-expression.

Did You Know?
Piercing the septum was extremely popular among ancient warrior tribes, perhaps because it gave the face a fierce and savage look.

Piercings to Enhance Sexuality

When male piercing was unusual in the West, some members of gay culture used ear piercing as a way of identifying like-minded individuals without calling too much attention to themselves. When not at a party or another location where they were trying to meet others, they could simply remove the jewelry, and no one was the wiser. Widespread acceptance of others' sexual preferences as well as an increased popularity of piercing meant that ear piercing lost this identification.

Yet some piercings are still linked with sexuality. Piercing intimate parts of the body to enhance sexuality is another reason for body art. Though a bit more extreme than most piercings, some people find that piercing genitalia or the breasts is a way to connect with their

For some teens, tattoos and piercings offer a way to express inner pain or alienation. At times, body art can also help fulfill a need for belonging and acceptance.

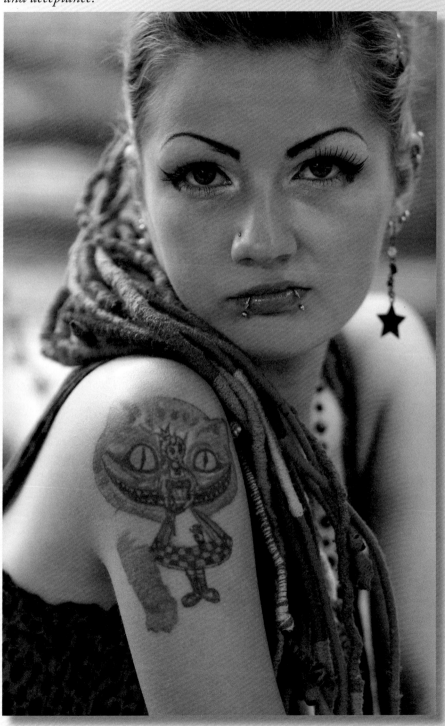

own sexuality or beautify body parts that society sometimes rejects as unclean. Piercing can proclaim an individual's willingness to accept his or her sexuality as important. Others find such piercings as empowering—facing the pain and fear allows for a new confidence. One man claimed, "At the time [of his piercing] I was still coming to terms with my sexuality, and I wondered how anyone could like me if even I wasn't sure about myself. . . . I now feel more self-confident about who I am and am more comfortable with myself and the identity I present to the public."[31]

Piercings Signify Group Membership

While piercings clearly indicate a rebellious soul, piercings are also symbols of identity that are easily recognizable by like-minded individuals. Thus, they can be rebellious while conforming to a group identity at the same time. Just as members of tribes use piercing as a way to show group identity, piercers feel that they have joined a group with attributes similar to their own. In the Western world, for instance, street gangs, punk rock groups, and rap stars have used piercings and tattoos to indicate group membership and a sense of identity.

One professional piercer suggests that the increase in piercing, far from making it mundane, enhances the sense that his "community" and its aesthetic is spreading in a positive way. As he relates, many people respond positively to his many visible piercings:

> The other night at the grocery store I received a big smile from the check out clerk who had a labret piercing [located directly under the lower lip] and an abundance of ear work. The day after Thanksgiving when I went holiday shopping I received the same response in a clothing store from one of the employees sporting big gauge plugs and an eyebrow ring. . . .

> Whether I'm piercing a 120 pound girl who wants to be like Christina Aguilera or my best boy who is all tattooed-out and pierced-back, when I line up my needle, check the angles, ask my client to take a "nice deep breath" and push the pin, the pierce disappears for a moment—lost in a fleeting pinnacle of pleasure and pain. And after the needle breaks the exit hole I can't help

but, for a fraction of a second, gaze into the pier-
cee's eyes to witness that experience which we both
now share. That's the deal. All of us who are pierced
share something. And, in my opinion, this shared
experience will make for some positive changes in
our culture.[32]

Damien, a young man with multiple piercings,
hits on two important meanings for pierced individu-
als: that the ritual itself is binding, and that it acts as
an initiation into a group. College student Alfredo Al-
vear has had his tongue, ears, nose, nipple, and other
body parts pierced. He claims that such piercings have
a larger impact on the psyche: "Even the simpler pierc-
ings, if nothing else, are a small rite of passage because
you have changed your body. It has that sort of side
effect."[33]

Finding Meaning

Over and over again, piercers say that they mark certain milestones
in their lives with a new piercing, thus recreating and redefining
that experience—whether good or bad—for themselves. One piercer
indicated that she has performed piercings on people to mark such
events as births, deaths, graduations, divorces, anniversaries, and
special occasions. Because such people choose repeated piercing as a
form of transformation, other piercers quickly identify them as kin-
dred spirits. This addiction to using body art is another identifying
characteristic. In *The Body Art Book*, Jean-Chris Miller speaks of this
addiction:

> You can really become addicted. It's hard to explain, but there's
> something about the anticipation of getting the work, the "en-
> dorphin rush" while the work is being done. . . . It's a feeling like
> no other in the world. I promise you, once you get a tattoo or
> piercing that you've thought long and hard about and that has
> real meaning for you, you'll *never* feel the same again. . . . It's part
> of your personality transformed into art.[34]

The more piercings, the more piercers identify with each other as a distinctive group. Such a group identifies with each other as enduring the pain that such self-expression necessitates, as well as the investment—both economic and emotional—that piercing inevitably indicates. This is why many have dubbed the current piercers as the "new tribal" or the "modern primitive"—members feel that they are part of a distinct tribe of intimates who believe that such rituals bring new meaning to their lives.

Chapter Three

Return of the Tribal

Throughout history, tribal cultures have used piercing as a part of important rituals. Historical evidence as well as current descendants who have been practicing piercing since ancient times reveal that tribes in the Middle East, Africa, and Latin America have used piercing as a part of religious and spiritual rituals.

Ritualized Piercings

Abundant evidence in the form of artistic relics as well as Western witnesses who wrote about these rituals is especially rich for the Aztecs and Mayans. These cultures pierced many different body parts, but they especially ritualized piercing of the tongue and male genitalia. These piercings, different than piercing done to enhance beauty, were meant to use pain to induce a trance-like state in which visions of their gods would manifest themselves to the piercers. One example is a type of Mayan vision quest, where, as reported by writer Wes Christensen, women "are shown pulling cords studded with thorns through holes punctured in their tongues. The bloody cords, along with the lancets used to open the wounds, are placed in low paper-filled platters."[35]

Numerous piercing tools, including stingray spines and awls of animal and human bone, have been found in Mayan graves. Mayan men ritually pierced their genitalia, believing the blood was the ultimate sacrifice to the gods. According to one account from Diego de Landa, a Spanish bishop who witnessed some of the Mayan ritual piercings: "They offered sacrifices of their own blood. . . . Other times they pierced their cheeks, at others their lower lips. . . . They pierced their tongues in a slanting direction from side to side and passed bits of straw through the holes with horrible suffering."[36]

Marking Life's Transitions

Rituals and ceremonies continue to be an important part of human life in societies all over the world. Today, for example, certain tribes in Africa, India, South America, Indonesia, and New Guinea pierce the nostril, lip, septum, and other body parts to mark a pubescent child's entry into adulthood. Certain groups in South America and Indonesia use ear cartilage piercings to mark the maturity and growth of females.

In her book, *Pagan Fleshworks*, Maureen Mercury discusses how initiates in tribal cultures undergo ritual separation from the tribe as part of their induction: "Adolescent boys are physically abducted from their villages and taken to sacred places away from that which is familiar. The point of the mock abduction is to separate them from the world of women (the world of their youthful innocence) and return them as men."[37]

In the modern world, religious and other ceremonies are also conducted to usher members of society into the "tribe." Rites in the Western world include bar and bat mitzvahs, confirmations, baptisms, wedding ceremonies, funerals, baby showers, and graduation ceremonies, among others. For some people in modern society, these rituals seem distant, impersonal, and commercialized. Some of these people have turned to body art such as tattoos and piercing to help them feel connected to themselves and their fellow "tribesmen"—others who are tattooed or pierced. Author Jean-Chris Miller explains this desire:

> Many people today get body art to mark transitions in their lives—such as turning eighteen, a death in the family, or surviving an illness or accident. These same rites of passage were once big events in which the entire community participated. Their importance was clear because of the rituals and ceremonies connected to them. Since we don't have those rituals anymore, many people find the permanency of a tattoo or other body modification a good way to mark a life-changing occasion.[38]

Meaning and Self-Identity

Many who use piercing and other body art to mark such life occasions were not raised with religious and cultural events that tied them to extended family and society. They find themselves adrift, with little understanding or desire to be part of an organized religion or other group that

Parents often have difficulty understanding why their teenage children are drawn to the idea of body piercing. Among the most perplexing piercings are those that are done on the tongue, lips, cheeks, and other highly visible locations on the body.

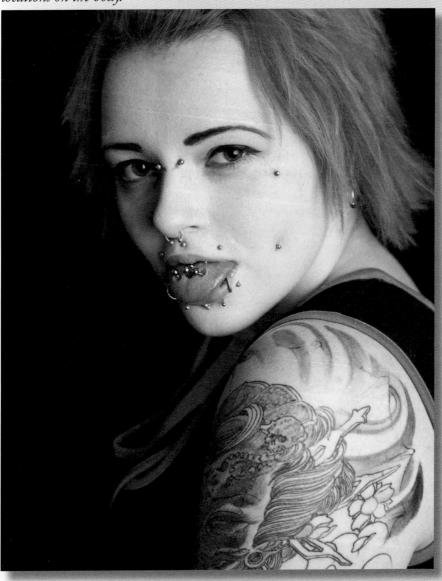

A Violation of Religious Principles?

Adherents of the Church of Body Modification have been met with controversy. For example, fourteen-year-old Ariana Iacono ran afoul of her school's dress code against piercing when she showed up at school wearing a nose ring. Ariana was promptly suspended, but her mother objected on the grounds that the school violated Ariana's religious and spiritual rights. Both parent and child belong to the Church of Body Modification. The principal ruled the nose ring was not necessary to Ariana's religious principles.

Ariana's mother does not think the school or anyone else should have a say in this matter. "Nobody has to agree with us," Nikki Iacono, thirty-two, said. "We have the same rights as anybody else does."

Calling the school's move religious intolerance and culturally backward, a minister of the church remarked that the principal is "basically saying that because he doesn't understand it, it can't be a sincerely held religious belief. . . . How do you judge someone's sincerity when it comes to religion?"

Quoted in Sarah Netter, "Student's Body Modification Religion Questioned After Nose Piercing Controversy," ABC News, September 16, 2010. http://ABCNews.go.com.

traditionally tied people together in worship. Teenagers, going through a period of exploring their self-identity and often feeling alienated and misunderstood, seem especially vulnerable to using body art or piercing to create meaning and a sense of self. Mercury explains how piercings function much like other rituals that mark transitions into adulthood:

> In our modern culture, there is no clear ritualized separation from parents, loving friends or partners, and the rest of the community when one is ready to cross the threshold into adulthood. In our culture, those ready to make the transition must create their own acts of separation and initiation—often performing these acts alone with no support structure. Tattoos, piercings,

and other forms of fleshworks have become a common modern initiation. If the initiate is under the legal age for fleshworks, lying and breaking the law creates an additional separation from the community. The process of getting a tattoo or piercing becomes the goal of the initiation: crossing a threshold of body sensation sometimes perceived as pain. The marking is worn as the proof of that crossing and of the accompanying transition.[39]

Clearly, many do not understand why a piercing can have such significance. This is probably especially true for the parents of teenagers who have chosen such an act to show their break from their parents. While piercings have gained in popularity, those who choose to abstain from them are often puzzled over why holes in one's body would lead someone to feel connected—especially when some piercings, such as those in the face, seem so alienating. Tribalectic, a piercing website, makes this statement about the "why" of piercing:

> A piercing is a self-inflicted wound. Whether we go through it for pleasure or pain, overcoming fear of pain, adornment, play, enhancement or whatever reason . . . we choose to modify our body and we choose when and how we want to do it. We are born naked. Our body comes into this world as a blank canvas and it can serve as a means to permanently document all the experiences, phases, stages and changes that slowly sculpt us into who we are.[40]

Those in the piercing community then, share group identification about the way they have personally chosen to celebrate key periods in their lives through body modification. Piercings and tattoos are permanent symbols that can be used to earmark a particular story. Author John A. Rush adds that this permanence is part of the attraction. "Tattooing, scarification, branding, implants, and self-mutilation are all, in one manner or another, statements about transitions, of getting rid of, altering, or adding something to one's life," he says. "Even if a piercing is done for aesthetic/artistic reasons,

Did You Know?

When the Bundi tribesmen of Papua New Guinea pierced young males as part of a rite of passage ceremony, the piercing was made with the thin end of a sweet potato plant.

this is still a statement to the world; you are now different, you have made a transition, and 'x' marks the spot."[41]

Regaining Control

Some pierced and tattooed women say that body modifications helped them overcome their fear, anger, and feelings of loss of control after sexual abuse, rape, or physical trauma. According to the Institute for Cultural Research:

> Many women have their bodies decorated or pierced in order to feel that they are reclaiming themselves after physical or psychological abuse. The process has two main objectives. Firstly, by decorating or modifying a body part, the individual places her mark on an area another person has "seized" without her consent. Secondly, by marking the body through ritual, an individual is lifted out of a culture he or she finds intolerable and is transported into a new clan which mirrors his or her sentiments.[42]

One rape victim summarized this desire by explaining, "I'm getting pierced to reclaim my body. I've been used and abused. My body was taken by another without my consent. Now by the ritual of piercing, I claim my body as my own. I heal my wounds."[43]

Professional piercers are not surprised by this trend. Since, for many, piercing is about transforming a bad experience by marking it with something they consider beautiful, it seems like the perfect ritual to help recovery. According to professional piercer Raelyn Gallina:

> I've pierced a lot of women who are getting [genital] piercing specifically because they're incest survivors, or they've been raped, or abused in some way, and they are wanting to reclaim their sexuality that's been stolen from them in a really nasty way. They want to reempower themselves and their sexuality and take that back. And turn it into something that's for themselves, something that was so degraded that changing it into something beautiful, where every time they look at themselves or their lover looks at them there's [a sense that] "That's beautiful."[44]

Some women feel that their sexual trauma was so profound and stole so much of their emotional selves that a piercing is the one way to regain at least their physical selves. As one victim of sexual and physical abuse puts it: "Coming from a very physically abusive background, and sexually abusive, the thing I really discovered is that the only thing I have true control over in this lifetime—everything else can fall apart—the only thing I have even the semblance of control over is my body. And how it looks. So I can make it bigger, I can make it smaller. I can scar it. I can pierce it. And some of those things I can make go away."[45]

Such musings seem similar to Western Christian religious rituals such as mortification of the body—the practice of hitting and scarring the body to gain control of impure or sexual thoughts. By ritualizing scarring the body, these women believe that they are gaining control over their self-hatred. Abuse survivor Becky notes, "Each modification has helped me feel more alive and sensitive. . . . My ghosts have been banished, and I have reclaimed my sexuality for myself."[46]

Self-Injury, Not Celebration

On the other hand, some people believe such ritual scarring is just another example of self-hatred, rather than the conquering of it. Some feminists and others believe these women need therapy, not piercings, and may be finding ways to further abuse themselves. Victoria L. Pitts summarizes this view: "While body modifiers themselves suggest that the violated female body can be rewritten in personally and politically meaningful ways, radical feminists argue in contrast that modifying the body is a straightforward replay of that violence."[47]

Feminist scholar Sheila Jeffreys writes that such ritualistic marking is self-mutilation, not celebration, especially since it stems from the ugliness of trauma:

Some of the enthusiasm for piercing in lesbians, gay men, and heterosexual women arose from the experience of child sexual abuse. Self-mutilation in the form of stubbing out cigarettes on the body, arm slashing and even garroting are forms of self-injury that abuse non-survivors do sometimes employ . . . the current fashionability of piercing and tattooing provide an apparently acceptable form for such attacks on the abused body. Young women and men are walking around showing us the effects of the abuse that they have tried to turn into a badge of pride, a savage embrace of the most grave attacks they can make on their bodies.[48]

Futuristic Visions of the Human Race

In *The Body Art Book*, Jean-Chris Miller explains how modern primitives blend futuristic imagery with the body art of traditional tribal cultures:

> Modern primitives incorporate the traditions of other cultures with futuristic visions of the human race. They embrace not only the old world of magic and mystery, but the new world of cybernetics and virtual reality. They take body modification to new heights by using the latest surgical and chemical technology to re-create themselves according to their own wishes. This could mean using a piercing to create a metal "beauty mark" on your face, or implanting metal spikes under your skin that stick out of the top of your head. It also includes extreme body modifications like implanting marbles under your skin for a more reptilian look.

Jean-Chris Miller, *The Body Art Book*. New York: Berkeley, 2004, p. 31.

Other Piercing Rituals Associated with Healing

The theme of reclaiming the body is mentioned over and over again among pierced individuals. In another form of healing—that of healing from illness—piercing is a prominent ritual. One piercee relates: "Personally, I made the choice to take control of the needles. Because of my blood disorder, I am a human pincushion. . . . So, my piercings are a way for me to dictate when, where, and why I am being poked with a sharp needle! For me it is a reclaiming of me; my body is not just a pincushion for medical uses. . . . It is a piece of artwork!"[49]

Another individual used piercing to commemorate and remember the horror of those who died in the 9/11 terrorist attacks on the World Trade Center. Canadian Brent Moffat, who got three thousand piercings on his body, explained, "This is done as a memorial to the people who lost their lives in the Twin Towers that fateful day . . . a remembrance of the lost men and women due to a senseless act of violence."[50]

Others have used piercing to bring together an intimate group to share in a ritual. A group of lesbian and gays who have modified their bodies developed a grief ritual for the victims of AIDS. One woman, Mandy, imitating a Native American ritual, had her body pierced with a large number of feathers and joined others in a ritualistic dance. Mandy says, "It was a very poignantly sad ritual. . . . We made a maze out of parts of the [AIDS] quilt. We walked through this maze and [people] came into a room and we were playing the Plague Mass and two people were chanting the names list and there were drummers and I had five dancers with me. I had these peacock feathers on strings all around my arms and down my back."[51]

Mandy's experience combined an invented group ritual to commemorate friends and others who had died from AIDS, as well as pieces of Native American tradition that used pain to more deeply focus upon the meaning of the ritual.

Did You Know?

Among the Kirdi, an ethnic group that inhabits parts of Cameroon and Nigeria, women wear long inserts in their pierced ears that they believe will protect them from supernatural forces.

Spiritual Enlightenment

Mandy's use of a Native American ritual to commemorate AIDS victims is not a new phenomenon. Tribal body art, as well as the desire to replicate tribal experience, began in the West in the mid-twentieth century. Piercing innovator Fakir Musafar named people who participated in this trend modern primitives. With the publication of the book *Modern Primitives*, contemporary society has seen the rise of the modern primitive movement. That movement postulates that ancient rituals like piercing and other forms of body modification enhance spirituality and bind people together.

Maureen Mercury writes that because contemporary society is desacralized, or bereft of deep spirituality and religiosity, many people use body art to create religious rituals for themselves:

> We live in a desacralized society today. Many have turned away from established religions and instead are trying to revive ancient rituals that were shed long ago, in an attempt to reconnect with the sacred. Life in a desacralized society demands drastic measures to restore us to the balance of our place in the cosmos in relation to the divine. Body modification is, for some, an attempt to create one's own rituals and symbols of meaning to achieve this balance, to create this felt sense of the divine within.[52]

So many people who engaged in body modification wanted to formalize the spiritualization of their practice that they formed a church in 2008 called the Church of Body Modification. According to the church's mission statement, it seeks to "educate, inspire, and to help lead our members along a path of spiritual body modification . . . [and] to practice our body modification rituals with purpose, to unify our mind, body, and soul, and to connect with our higher power."[53] The church also states that body piercings and other forms of body modification are perhaps "one of the safest and most . . . responsible ways to stay spiritually healthy and whole."[54]

While some think the church far-fetched, others see its legitimacy. Gary Laderman, professor and chair of the Department of Religion at Emory University, says about the Church of Body Modification, "I think there's much more to religious life and culture than God. . . . To me, this is a great illustration of an alternative form of religious prac-

tice and commitment than what we're used to."[55] For many adherents of body modification, the spiritual aspect of the practice cannot be denied, though it might not be understood by the mainstream population just yet.

The Ritual of Pain

Native cultures have developed many rituals around the pain of piercing, believing that such pain is transformed into a powerful spiritual and religious experience. According to the Institute for Cultural Research, "Pain can alter the state of consciousness in such a way that mystical or magical powers are obtained: Making use of pain was an ancient and widespread practice in both shamanic and sorcery practices."[56]

One ritual called the Okipa was originally practiced by the early American Mandan tribe until the late 1880s, although it is still practiced today by some modern-day piercers. The Mandan deeply pierced each nipple through the chest and attached hooks to the piercing. The piercee was then suspended by hooks from the roof of their lodge, and then spun around in circles until he lost consciousness. Sometimes weights were attached to the legs to make it even more tortuous. When they woke up, they had their left pinkie chopped off with a hatchet. The Mandan believed that this particular piercing ritual enabled them to achieve the approval of the gods.

In modern India and Malaysia, Tamil-speaking Hindus use piercing as part of an ancient religious festival called Thaipusam. The festival is commemorated with a period of abstinence and fasting to cleanse the body of sin in honor of Lord Murugan, a son of Shiva, one of the most important Hindu gods. During the festival, religious devotees bring tributes, usually in the form of pots filled with milk and offerings of fruit, to the god. Some chosen individuals carry elaborate frameworks on their shoulders called kavadis, which have long chains hanging down with hooks at the end that are pushed into their backs.

Did You Know?

Widely practiced in Australia and Papua New Guinea, nasal septum piercings are believed to expand the five senses and lead to a special ability to perceive the supernatural.

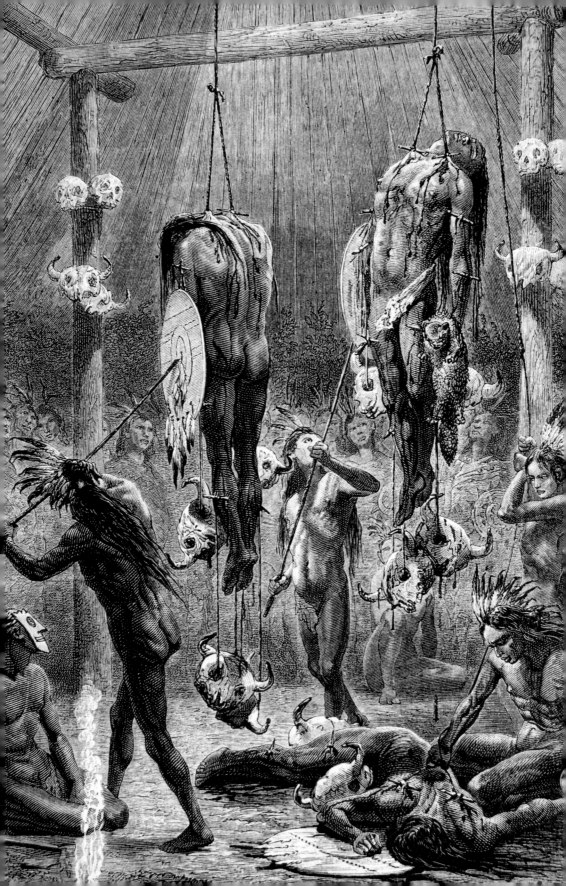

The chains are heavily weighted, and the kavadi bearers often also balance a pot of milk on their head to bring to the god. Some also have chariots attached to the kavadi that they then pull through the street. Some of the kavadi bearers also have two skewers—one through their tongue and one through their cheeks—to renounce the power of speech. It is thought that enduring pain helps one renounce the body and also brings one closer to God.

One kavadi bearer, Carl, explains the experience this way:

> Hindus believe that each soul has the spark of the divine within, so in actual fact in one way it's a journey outside but also a journey inside . . . so you're in immediate contact with the divine for maybe a short blissful period while you're actually carrying this kavadi. . . . While you're in this state of trance you're in a trance of divine communion and that imposes this feeling of ecstasy upon you which makes you aware of your ultimate objective.[57]

Another modern-day pain ritual involving piercing is the Phuket Vegetarian Festival in Phuket, Thailand. During the month-long festival during the ninth lunar month of the Chinese calendar, people abstain from meat and various stimulants to bring good health and peace of mind. Thousands of men and women gather each year to perform a ritual facial piercing to honor the forest spirits. They puncture their cheeks with various items, including knives, skewers, household objects, and other unlikely items such as ladders and even machine guns. Piercees believe that the gods will protect them from harm and scarring.

Tradition and Connection

Some people speculate that the reason such ceremonies appear to alter consciousness and lend a feeling of spiritual enlightenment relates to the endorphin rush associated with them. As John A. Rush writes in his book

Spiritual Tattoo: A Cultural History of Tattooing, Piercing, Scarification, Branding, and Implants:

> Pain and suffering, whether voluntary or forced, are used in many traditions as a form of spirituality, but the frequency with which they are found [in Judaism, Christianity, Islam, and other religions] speaks for a long, long tradition. Why? This is not an

A devotee of the Hindu Thaipusam festival engages in acts of devotion. These acts include skewers through his tongue and cheeks, carrying a pot of milk on his head, and piercings on his chest and back that are weighted down with limes.

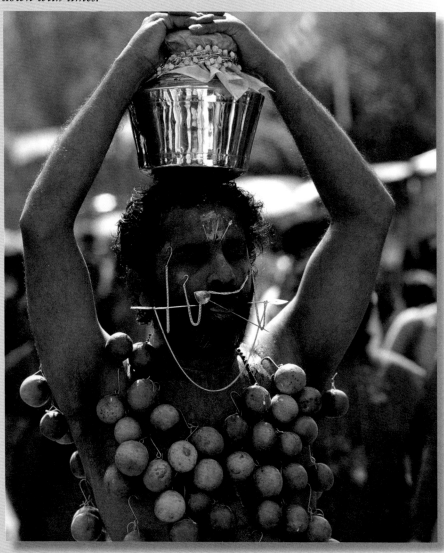

easy answer, but we can begin by noting that pain and suffering lead to the dumping of endorphins (the opiates of the brain), and usually if not always (depending on the level of the pain) there is a period of calmness as the opiates are reabsorbed or metabolized. This would have been recognized by our ancient ancestors upon experiencing injury and subsequent care from others. When people recover it is as if something has been released, added to, or somehow manipulated in the body.[58]

The ritual of pain is not isolated to tribal culture or religious pilgrims. Modern piercers also contend that a piercing brings about a spiritual state. As one piercer named Drew states:

I have always thought of body piercing as a spiritual experience—something one endures in order to reach a state of higher consciousness. The immediacy of the moment of piercing has the power to physically reconnect the piercee with his or her body. Perhaps it's the pain of the moment that reawakens the dull mind to its surroundings. Or perhaps the piercee, in worrying about the pain, builds up the moment of piercings so much that when the needle finally goes through their skin, all their fears are allayed and they feel momentary euphoria. Either way, it is clear that there is something about the instantaneous action of piercing that can cause significant changes in a person's psyche.[59]

For many piercers, then, the practice is deeply tied to the need for a larger community, sense of belonging, and desire to bring a new type of spiritual and religious experience to their lives. For some, such desires create a passion to go to deeper extremes.

Chapter Four

Piercing Today

Though body piercing has risen dramatically in recent years, other than ear piercing, it remains a minority practice. Reliable statistics are hard to come by, but in a 2012 Harris Poll, 49 percent of those surveyed reported having pierced ears, 7 percent reported a piercing elsewhere on the body, and 4 percent reported a facial piercing, excluding ear piercing. The largest study to date, conducted by Pew Research, reported an overall body piercing rate (not counting ears) of about 36 percent, with women reporting more body piercing than men. Not unlike tattoos, which have gained such acceptance that people of any age or gender may have one, multiple piercings are also becoming less unusual.

Types of Piercings

Piercings, like many body modifications, range from the most common to the most extreme. Today few people find multiple ear piercings out of the ordinary. Most people would likewise find a tongue piercing, eyebrow piercing, lip piercing, belly-button piercing, or an open hole through the earlobe less common, but similarly unsurprising. A person has to have all of the above, and a cheek piercing, bar through the septum, or several eyebrow piercings, to seem highly unusual. Other piercings, though regarded as a bit more extreme, are mostly hidden from view, such as piercings through the nipples and genitalia.

Piercings' gain in popularity has largely standardized the practice. Today certain piercings carry names, and certain practices have a specific terminology. For example, a surface to surface piercing (back of wrist, cheek, neck) describes piercings where both the entrance and exit holes

are made through the surface of the skin so that the jewelry appears to be sitting on top of the skin.

Some piercings carry the name of the person who first had the piercing or the name of a piercer. For example, bridge piercings describe a horizontal piercing that spans the top of the nose between the eyes, but is also called an Erl after the first man known to have gotten this piercing. Though it is impossible to describe all of the different piercings, some of the most common are described below.

Did You Know?

Multiple studies conducted in the late 1990s and early 2000s indicate that what people value most about piercings and other forms of body modification is being different or unique.

- Lip piercings carry different names depending on where on the lip they are done. A beauty mark piercing is a single stud on the top lip to emulate the beauty mark that female stars such as Marilyn Monroe, Madonna, and Cindy Crawford are well known for. A labret is a piercing below the lip but above the chin, a snakebite is two piercings on opposite sides of the bottom lip, and angel bites are two piercings on the upper lip.

- Ear piercings also have a variety of names, depending on their placement on the ear. A helix is a piercing in the upper part of the ear. An industrial is when two piercings at the top of the ear are connected with a bar. A stretched piercing describes an earlobe piercing that has been stretched using gauges and plugs to widen the hole. This piercing, once unusual, is gaining in popularity. When it is possible to see through the earlobe because the hole has been widened to allow the wearing of a hollow object, it is called a flesh tunnel.

- Nose piercings' popularity has risen among women. The most typical piercings are through the nostril and the septum, though the Erl is also common. A septum piercing does not actually pierce the septum, but pierces the soft flesh in the front of the septum.

- A piercing that has become more common is the tongue piercing. The middle of the tongue is pierced, usually with a metal bar that has two round balls at either end.

Pierced ears are still probably the most common type of body piercing. Of these, stretched earlobes and flesh tunnels (pictured) are also gaining in popularity.

Some piercings are far more unusual and remain so. Madison piercing is named after the first person to wear a horizontal piercing below the collarbone, Madison Stone. Stone is now a tattoo artist with her own parlor in Burbank, California. She tells the history of her piercing:

My hair would always get tangled up in my necklaces; I went into The Gauntlet [a well-known tattoo parlor] and asked if we could just pierce the hollow of my neck so I could hang my charms from it—they looked at me in amazement (probably because they hadn't thought of it yet!), then we marked it out and pierced it. It healed like an absolute dream. I had all sorts of custom charms, crosses, and diamonds made for it. I had no idea it had been named after me until some time later. The flattery of that is inconceivable for most people, to know that you will be immortal because of some simple decision just to make your life easier and express yourself.[60]

Physical Risks of Body Piercing

All body piercings are susceptible to infection if aftercare instructions given by the piercer are not followed. Even with proper care, some people may experience problems such as an allergic reaction to certain metals, swelling, bleeding, scar tissue, and tearing, among other issues. Even with proper care, navel piercings, for example, are prone to infection, and can they take about a year and a half to heal completely. Healing is complicated by the fact that the navel is involved whenever a person bends forward, and clothing can often interfere with the healing process.

Infection is far and away the biggest risk of any piercing. According to the *Journal of the American Medical Association*:

> Any time the skin is penetrated, potential for infection exists. Typical signs of infection include pain, tenderness, redness, and foul-smelling drainage from the site of the piercing. Such infections can lead to serious complications such as abscess formation at the site or spread through the bloodstream to distant sites, including the heart valves. . . . The instruments used to do body piercing may become contaminated with blood, body fluids, or other infectious materials. This may not be visible to the naked eye. Infections (such as hepatitis) can occur if the instruments are not properly cleaned and sterilized.[61]

Tongue piercing, for instance, is fraught with potential problems. It is a complex area because the tongue is filled with arteries and veins which the piercing cannot interfere with. In addition, the metal ball attached to the bar through the tongue has to be far back enough that it does not hit the teeth but not far enough that it causes a gag reflex. Finally, because plaque can attach itself to tongue jewelry, the bar must be flossed, just like the teeth.

As Karen L. Hudson, a professional piercer, body art advocate, and author of *Living Canvas: Your Total Guide to Tattoos, Piercings, and Body Modification*, says:

> Tongue piercing is my least favorite of all of them. Not because I don't think they look good—I do. My husband and I both had our tongues pierced for a few years. I had a lot of irritation with

mine—either my tongue or the roof or the base of my mouth under the tongue was always sore. It seemed to go in a rotation of pain. And we both managed to break a couple of teeth from accidentally biting down on the ball. Four fillings and two root canals later, I have to say that I do not encourage people to get their tongues pierced.[62]

In addition, tongue piercings are prone to infection. An Israeli man died when an infection stemming from his tongue piercing spread into the bloodstream. Professor Hans Zola at the University of Sydney says this is extremely rare but explains, "You're sticking a metal object through both sides of the tongue and what that's going to do is obviously create a pathway via which bacteria from the mouth, from the saliva, which is pretty grubby, can gain access to the tongue and then spread through the tongue through to some other tissues."[63]

Minimizing Risk

Individuals can minimize the risk of infection by going to an accredited piercing parlor, following the care instructions they are given, and removing jewelry if an infection at the piercing site is persistent. And a number of national and international organizations for professional body artists of all types have emerged, in part to help mitigate risks. For example, the Association of Professional Piercers is an international health and safety organization formed to provide a professional association that sets standards for piercers and educates the public about piercing. The association gives first-time piercers information on what they should look for when they go to a parlor to be pierced. Even armed with this information, first time piercers should also talk to a doctor if they have any preexisting medical conditions that could affect the healing process, such as diabetes or other health conditions. Some health conditions should preclude piercing, and in some states a person cannot give blood if he or she has a piercing.

One tragic story illustrates the need to know about personal medical conditions and how they

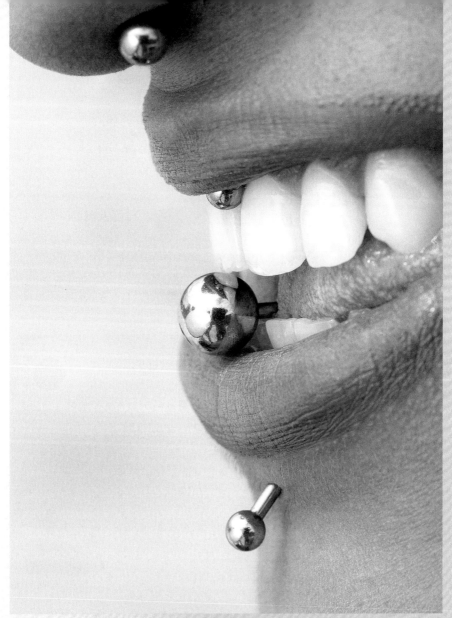

Tongue piercings are more complicated to do than some other piercings because the tongue is filled with arteries and veins. Piercers also have to make sure the jewelry is far enough back that it does not hit the teeth but not so far back that it triggers a gag reflex.

may be affected by a piercing. For example, Daniel Anderson was a young man with a congenital heart defect. As an infant he had two life-saving operations but had been without symptoms his entire life and was unaware that his condition could carry risks. Anderson died from an infection when his lip piercing became infected, largely because he was

uninformed about the impact his past health problems could have on his decision to get a piercing. As Hudson says, "If you have a preexisting condition that could, in any way, make a mild infection life threatening, getting pierced becomes a big deal. Piercings—even ones done professionally—are often subject to minor infections. They can appear out of nowhere and be much worse than you think. Daniel and his family had no idea how badly his body was being ravaged by infection."[64]

Any infection should be taken seriously. Stephanie Edington, for example, had her nipples pierced, and they quickly became infected. The infection allowed an entry point for serious necrotizing bacteria—bacteria that rots the flesh—to gain hold, spreading throughout her breast. Edington ended up having to have a mastectomy and a removal of flesh up to her collarbone to save her life.

Private Piercings Going Public

As more and more metal detectors make their way into courthouses, museums, schools, and transportation venues of all kinds, some worry that private body piercings, such as nipple or genital piercings, will set off metal detectors during routine security screenings. Celebrity Nicole Ritchie, for example, was forced to undergo a breast inspection after her nipple ring set off a detector at an airport in Nevada. Alicia Cardenas, who owns a body piercing shop in Denver, describes a similar experience as she passed through security at an airport in Oklahoma: "They get to my breasts [with a handheld wand] and the thing goes off and there's a whole bunch of hollering and a bunch of people come over." Cardenas, who was forced to remove the rings before she could proceed through security, says, "Had I been a less confident person, I would have been a lot more shook up. As it was, it was an absolute embarrassment to have my private life displayed."

Quoted in Diane Mapes, "Private Piercings Raising Public Alarm," NBC News, May 15, 2008. http://NBC News.com.

Other risks are related to where a person has a piercing. Cheek piercings, for example, can interfere with major muscle groups and blood vessels in the face. They can also affect the parotid gland, one of the salivary glands that is largely responsible for the body's ability to break down food. If the parotid gland is pierced when a cheek is pierced, saliva may continuously weep through the piercing site, complicating the healing process and perhaps even preventing the piercing from healing.

Laws and Oversight

Almost all states have some form of legislation regulating body art. Thirty-eight states have specific laws regarding piercing. Many of these laws prohibit body piercing of a minor without written consent from a parent. For example, in 2012 New York State signed into law a bill requiring a minor to have written parental consent before getting a body piercing. As Senator Joseph E. Robach, who cosponsored the bill, said, "As body piercings can often result in infection and a permanent scar, it seems logical that parents should be involved in the decision. This law will help educate both parents and children of the potential risks of piercings and help them make informed decisions together."[65] Many states also have laws that prohibit a person from being tattooed or pierced while intoxicated.

In most states, piercing and tattoo parlors are regulated by the health department in the same way that hair and nail salons are. Before such a business is allowed to open, a health inspector checks the premises to make sure that the shop is sanitary and has a way of reliably sterilizing the instruments. Piercing parlors must also prove that they do not reuse needles, for example. In Florida, a piercing salon must obtain a license each year from a county health department. At least once a year, salons undergo an inspection to make sure that piercers are trained in safety, sanitation, sterilization, and methods for preventing the spread of infectious diseases.

Did You Know?
According to Stephen Ross of the University of California–Los Angeles Medical School, minor complications occur in about 20 percent of pierced individuals, while major complications occur in about 3 percent of pierced individuals.

In addition, piercers attempt to keep information flowing with their own international organization, the nonprofit Association of Professional Piercers. Becoming a member of the association is completely voluntary, and it sees its mission as more as a disseminator of information, rather than a regulatory or licensing body. The association produces brochures, has regular meetings, and offers classes to its members.

Even with this oversight, many piercers warn that it is up to the piercee to examine the studio and interview the piercer to make sure they are qualified, particularly for the type of piercing that the individual is seeking. Hudson offers this advice: "Ask for a tour of the place—if they're happy to show you around, especially if they point out their sterilization area, that's a good indication that they have nothing to hide and want you to feel comfortable. If they don't show you the sterilization area, ask to see it. If they hesitate or seem disgruntled by the request, leave."[66]

Did You Know?
A number of states have made it illegal to use piercing guns on body piercings because the guns cannot be sterilized in an autoclave, a machine designed to kill harmful bacteria.

Workplace Issues

While piercing has gained in acceptance, employers may still have difficulty with hiring a person who has visible piercings. People with piercings often complain of discrimination at school or the workplace. Facial piercings, especially, are visible and can cause problems at places with dress codes. Fearing that customers will be offended, some companies will not hire individuals with body piercings for positions that have contact with the public. On the other hand, more progressive workplaces such as Whole Foods Market, Trader Joe's, and some information technology and software companies have no such qualms. Some think employees' tattoos and piercings add a youthful rebelliousness that aids in the companies' unconventional image. In fact, a website called The Modified Mind: Employment Line lists companies that accept, and even embrace, their employees' body art. The CEO of one small company states, "A decade ago, showing off tattoos and body piercings would be a surefire way

to get your resume placed in the 'No Way!' pile. But times have changed. Those making today's hiring decisions are younger and not as adherent to traditional workplace appearance."[67]

The workplace may have to change, as college students have become more likely to be tattooed and pierced. Research has found that 23 percent

The best way to minimize health risks is to make sure the piercing artist is accredited and follows standard hygiene practices including wearing gloves during the entire procedure. If an infection occurs it should be taken seriously.

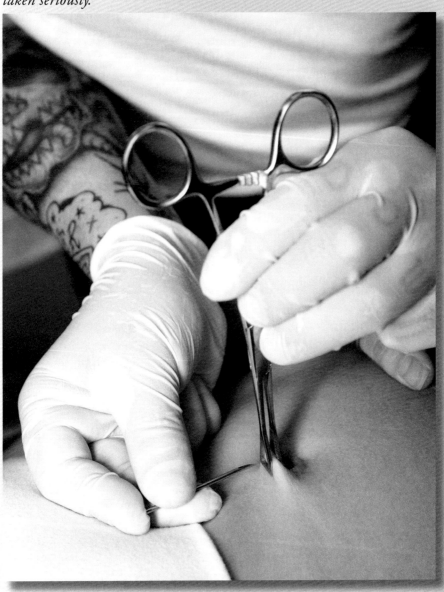

How Much Does Getting a Piercing Hurt?

In her book *Living Canvas: Your Total Guide to Tattoos, Piercings, and Body Modification*, author Karen L. Hudson addresses the question of how much pain piercings cause:

> That's usually the first thing a person wants to know before they get one. It's a fair question, but not one that's easy to answer. It depends on where you're getting the piercing, how much tissue the needle has to go through, and what your personal pain threshold is. All of these factors vary from person to person and can make even identical piercings a very different experience.
>
> Piercing through cartilage tends to hurt more than it does through soft tissue, but even that is subjective. My industrial was really painful, but my tragus [the small, roundish, protuberance of cartilage just outside the ear canal] barely hurt at all—and they're both cartilage piercings. The dermal anchors I got through the soft tissue of my chest were pretty intense, whereas my eyebrow piercing was very easy. Piercings that I had found painful, others have told me were not bad at all, and vice versa. It's difficult to say whether you will find a particular piercing very painful or not.

Karen L. Hudson, *Living Canvas: Your Total Guide to Tattoos, Piercings, and Body Modification*. Berkeley, CA: Seal, 2009, p.121.

of college students have one to three tattoos, and 51 percent a piercing (this statistic does not include pierced ears on women). In addition, 36 percent of young people aged eighteen to twenty-nine sport tattoos.

Still, some more traditional companies have taken issue with body art. Bankers, lawyers, accountants, and clergy members rarely support body art. According to Sue Thompson, a workplace consultant, "While

visible tattoos and body piercings have become more acceptable in mainstream society, they can still carry a stigma in the white-collar workplace. . . . When you present yourself in the workplace, you need to recognize that people will naturally make a judgment about how you look."[68]

In 2001 Kimberly Cloutier found herself in just such a position when she sued Costco Wholesale Corporation for telling her she had to remove her eyebrow ring because it violated the company's dress code. Cloutier contends that the eyebrow ring is "not just an aesthetic thing. . . . It's your body; you're taking control of it."[69]

The court did not agree with Cloutier. The judge ruled that the company had a right to set dress code standards and that Cloutier was flouting the policy:

> It is axiomatic that, for better or for worse, employees reflect on employers. This is particularly true of employees who regularly interact with customers. . . . Even if Cloutier did not regularly receive any complaints about her appearance, her facial jewelry influenced Costco's public image and, in Costco's calculation, detracted from its professionalism. . . . Costco has made a determination that facial piercings, aside from earrings, detract from the "neat, clean, and professional image" that it aims to cultivate. Such a business determination is within its discretion.[70]

Can Piercing Become an Addiction?

For some, body piercing starts out as a fun way to be unique but turns into an obsession to procure ever more piercings—the so-called steel addiction. People who repeatedly seek out new piercings claim many reasons, including that they are addicted to the pain it brings or to the endorphin rush that follows. As one young teen explains:

> I'm 14, almost in high school, and have more piercings than anyone else I know. I have snake bites, nose, double eyebrow, tongue, my ears are stretched to a size 0, two piercings above my stretched ears, and I have my cartilage pierced. Even the dudes at the tattoo shop, who pierced my tongue didn't have as many! It kind of worries me, like maybe I'm going too far.

. . . I remember a few years ago, when I'd look at these people on the internet that have multiple facial piercings and being repulsed by it. Now they're like my idols. I just WANT everything pierced. Even thinking about it gives me this like, mental boost.[71]

For some, piercing is a competition. Elaine Davidson, who was born in Brazil in 1969, holds the world record with six thousand piercings. Her face and ears and other body parts are covered in piercings. Others compete for the most piercings in a single sitting. Viewing these people on the Internet can be quite shocking.

Body Suspension

One form of piercing combines piercing the flesh with a Native American tradition, called body suspension. In a body suspension, a person is hung from his or her flesh from hooks. The practice of body suspension has been around for approximately five thousand years and is thought to have originated in India. The ancients used body suspension as a ritualistic practice, usually to grow closer to God, as a religious meditation, or as a form of penance or tribute to god. Today people sometimes associate it with religious or spiritual ritual or simply use suspension as a way to conquer obstacles that they see in their lives. Cere Coichetti, head of the New York chapter of Rites of Passage, a group that helps people suspend themselves, describes his first suspension:

I wanted to see if I was tough enough to do it. . . . It came down to a challenge to myself, a test of strength. If I can put hooks in my body—suspend my near 300-pound frame from little hooks—then there's nothing I couldn't do. I thought it was going to hurt. I thought it was going to suck. I thought it was going to be the most traumatizing experience of my life. . . .

Once I got into the air, once they lifted me up, it was the most peaceful, serene, blissful experience I've ever had. And it was kind of like, throughout life, you tend to take on negative energy—by energy I could mean stress—stress from your job, stress from home, if you're married, if you've got kids—just stress. And this was just the ultimate stress release. . . . The second I came down, I knew I wanted to go back up.[72]

It takes a group of people to help with a suspension, and those that rig the suspension are called suspension artists. They must figure out the person's mass and weight, and where to insert the hooks so that they can hang from the hooks with their weight perfectly balanced. Though the skin stretches, the risk of ripping is small since the hooks are inserted under the dermis and into the subcutaneous fatty tissue. If the skin does tear, it does so slowly, and the person is lowered to the ground.

For many who practice it, it can become a transformative religious experience. Body piercer Abraham Street, who is also president of Sacred Mark Sanctuary, another suspension group, claims, "People have described 'trancing out,' seeing colors or lights, leaving their body, and other shamanic experiences."[73]

From decoration to transformation, piercing has a long history and a newly invigorated future. With piercing losing its stigma and more people interested in it, it may become an ever more common phenomenon.

Source Notes

Introduction: A Little Rebellion or a Sign of Deep Distress?

1. Quoted in Deb Holland, "Tattoos, Piercings Get More Popular with Teens," *Rapid City (SD) Journal*, July 31, 2011. http://rapid cityjournal.com.

2. Quoted in Diana Appleyard, "Where Did My Little Girl Go? She Wanted for Nothing. Now Diana Appleyard's Daughter Is a Goth with Ten Piercings," *Daily Mail*, October 25, 2011. www .dailymail.co.uk.

3. Michelle Robertson, "Piercing the Way to Maturity," *Daily Californian*, February 27, 2013. www.dailycal.org.

4. Keren Skegg et al., "Body Piercing, Personality, and Sexual Behavior," *Archives of Sexual Behavior*, February 2007. www.ncbi.nlm .nih.gov.

5. Cap Szumski, interview with the author, February 26, 2013.

Chapter One: Body Piercing Loses Its Stigma

6. Jean-Chris Miller, *The Body Art Book*. New York: Berkeley, 2004, pp. 28–29.

7. Miller, *The Body Art Book*, p. 29.

8. Leviticus 19:28, King James Version.

9. 1 Corinthians 6:19, King James Version.

10. Quoted in V. Vale and Andrea Juno, *Modern Primitives: An Investigation of Contemporary Adornment & Ritual.* San Francisco: Re/ Search Publications, 1989, p. 36.

11. Victoria L. Pitts, *In the Flesh: The Cultural Politics of Body Modification.* New York: Palgrave Macmillan, 2003, p. 92.

12. Elayne Angel, *The Piercing Bible: The Definitive Guide to Safe Body Piercing*. Berkeley, CA: Crossing, 2009, p. 14.

13. John Leo, "The 'Modern Primitives,'" *U.S. News & World Report*, July 23, 1995. www.usnews.com.

14. Quoted in Pitts, *In the Flesh*.

15. Quoted in *Vibe Vixen*, "Interview with Janet Jackson," March 2007. www.vibevixen.com.

16. Rufus C. Camphausen, *Return of the Tribal: A Celebration of Body Adornment*. Rochester, VT: Park Street, 1997, p. 33.

17. Lawrence Rubin and Michael Brody, "Tattoos and Body Piercing: Adolescent Self-Expression or Self-Mutilation?" *Psychology Today*, July 2, 2009. www.psychologytoday.com.

Chapter Two: Piercing as a Way to Forge Identity

18. Chris Rainier, *Ancient Marks: The Sacred Origins of Tattoos and Body Marking*. San Rafael, CA: Earth Aware Editions, 2006, p. 185.

19. Quoted in Rainier, *Ancient Marks*, p. 14.

20. Miller, *The Body Art Book*, p. 30.

21. Miller, *The Body Art Book*, p. 31.

22. John Michael Byrne, "Tattooing and Piercing in the Punk Subculture." http://sites.google.com.

23. V. Vale and Andrea Juno, *Modern Primitives: An Investigation of Contemporary Adornment & Ritual*, p. 10.

24. Miller, *The Body Art Book*, p. 13.

25. Lisiunia A. Romanienko, *Body Piercing and Identity Construction*. New York: Palgrave Macmillan, 2011, p. 5.

26. Quoted in Pitts, *In the Flesh*, p. 70.

27. LuAnn Pierce, "Body Piercing: Understanding Kids Today," *SelfhelpMagazine*, September 18, 2012. http://selfhelpmagazine.com.

28. Marthe Deschesnes, Stephanie Demers, and Philippe Fines, "Prevalence and Characteristics of Body Piercing and Tattooing Among

High School Students," *Canadian Journal of Public Health*, July/August 2006. http://journal.cpha.ca.

29. Angel, *The Piercing Bible*, p. 6.

30. Quoted in Angel, *The Piercing Bible*, p. 7.

31. Quoted in Angel, *The Piercing Bible*, p. 9.

32. Damien, "Piercing Holes in the Mainstream," Tribalectic, November 30, 2000. http://community.tribalectic.com.

33. Quoted in Damien, "Piercing Holes in the Mainstream."

34. Miller, *The Body Art Book*, p. 32.

Chapter Three: Return of the Tribal

35. Quoted in Vale and Juno, *Modern Primitives*, p. 80.

36. Quoted in Vale and Juno, *Modern Primitives*, p. 80.

37. Maureen Mercury, *Pagan Fleshworks: The Alchemy of Body Modification*. Rochester, VT: Park Street, 2000, p. 27.

38. Miller, *The Body Art Book*, p. 29.

39. Mercury, *Pagan Fleshworks*, p. 27.

40. Tribalectic, "Body Piercing—Evolution or Revolution?," July 31, 2002. http://community.tribalectic.com.

41. John A. Rush, *Spiritual Tattoo: A Cultural History of Tattooing, Piercing, Scarification, Branding, and Implants*. Berkeley, CA: Frod, 2005, p. 55.

42. Quoted in Vale and Juno, *Modern Primitives*, p. 15.

43. Quoted in "Body Modification and Body Image," Body Project, Bradley University. http://thebodyproject.bradley.edu.

44. Quoted in Pitts, *In the Flesh*, p. 64.

45. Quoted in Pitts, *In the Flesh*, p. 62.

46. Quoted in Pitts, *In the Flesh*, p. 65.

47. Quoted in Pitts, *In the Flesh*, p. 74.

48. Quoted in Pitts, *In the Flesh*, p. 74.

49. Quoted in Angel, *The Piercing Bible*, p. 8.

50. Quoted in *Kerrville (TX) Daily Times*, "3000 Piercings as 9/11 Tributes," September 7, 2004. www.dailytimes.com.

51. Quoted in Pitts, *In the Flesh*, p. 111.

52. Mercury, *Pagan Fleshworks*, p. 3.

53. Church of Body Modification, "Mission Statement." http://us cobm.com.

54. Church of Body Modification, "FAQ." http://uscobm.com

55. Quoted in Sarah Netter, "Student's Body Modification Religion Questioned After Nose Piercing Controversy," ABC News, September 16, 2010. http://ABCNews.go.com.

56. Quoted in Vale and Juno, *Modern Primitives*, p. 15.

57. Quoted in BBC, "Thaipusam," September 9, 2009. www.bbc .co.uk.

58. Rush, *Spiritual Tattoo*, pp. vii–viii.

59. Drew, "The Fear of Pain and the Path to Enlightenment," Tribalectic, October 31, 2000. http://community.tribalectic.com.

Chapter Four: Piercing Today

60. Quoted in Karen L. Hudson, *Living Canvas: Your Total Guide to Tattoos, Piercings, and Body Modification*. Berkeley, CA: Seal, 2009, p. 170.

61. Janet M. Torpy, et al., "Body Piercing," *Journal of the American Medical Association*, February 25, 2004. http://jama.jamanetwork .com.

62. Hudson, *Living Canvas*, p. 163.

63. Quoted in Jennifer Mason, "Tongue Piercing Infection Death Prompts Warning," ABC News, October 18, 2009. www.abc.net .au.

64. Hudson, *Living Canvas*, p. 128.

65. Governor Andrew M. Cuomo, "Governor Cuomo Signs Bill to Protect Teens from Health Risks of Body Piercing," press release, July 30, 2012. www.governor.ny.gov.

66. Hudson, *Living Canvas*, p. 190.

67. Quoted in *Central Valley Business Times*, "Could Tattoos Make Tough Job Search Tougher?" July 22, 2010. www.centralvalley businesstimes.com.

68. Quoted in Ladders, "Tattoos & Piercings in the Workplace," March 8, 2011.www.career-line.com.

69. Quoted in *Worldwide Religious News*, "Employee, Fired for Eyebrow Ring, Sues Costco, Claiming Religious Discrimination," October 16, 2002. http://wwrn.org.

70. Quoted in Alison Wellner, *Workforce*, "Costco's Appearance Crusade," September 7, 2011. www.workforce.com.

71. Quoted in Experience Project, "I Am Addicted to Piercings: Downhill from Here," March 20, 2012. www.experienceproject .com.

72. Quoted in Wyatt Marshall, "The Therapeutic Experience of Being Suspended by Your Skin," *Atlantic*, September 21, 2012. www .theatlantic.com.

73. Quoted in "Ancient Tribal Rituals Meet Modern Body Piercing at SuspenDC," September 5, 2007. www.suspendc.com.

For Further Research

Books

Elayne Angel, *The Piercing Bible: The Definitive Guide to Safe Body Piercing.* Berkeley, CA: Crossing, 2009.

Body Piercing: The Body Art Manual. Edison: NJ: Chartwell, 2010.

Karen L. Hudson, *Living Canvas: Your Total Guide to Tattoos, Piercings, and Body Modification.* Berkeley, CA: Seal, 2009.

Alessandra Lemma, *Under the Skin: A Psychoanalytic Study of Body Modification.* New York: Routledge, 2010.

Jean-Chris Miller, *The Body Art Book.* New York: Berkeley, 2004.

Lisiunia A. Romanienko, *Body Piercing and Identity Construction: A Comparative Perspective.* New York: Palgrave Macmillan, 2011.

Internet Sources

Katherine Bernard, "Rebel Rebel: Fashion's Fixation on Multiple Piercings and Tattoos," *Vogue Daily*, February 2, 2012. www.vogue.com.

Glenn D. Braunstein, "Drilling Down on Body Piercing Health Issues," *Huffington Post*, May 21, 2012. www.huffingtonpost.com.

Daily Mail, "Surgeon Blasts New 'Corset Piercing' Fad Where Pierced Skin Is Pulled Together with Ribbons," May 6, 2011. www.dailymail .co.uk.

Allegra Kogan, "For Underage Piercings on St. Marks Place, Days Are Numbered," *New York Times*, August 17, 2012. www.nytimes.com.

Olney (IL) Daily Mail, "Body Piercing 101," December 11, 2012. www.olneydailymail.com.

Shari Roan, "The Lowdown on Body Piercing: Dermatologists Study, Offer Checklist," *Los Angeles Times*, February 24, 2012. http://articles .latimes.com.

Bonnie Rochman, "Why I Took My 7-Year-Old to a Tattoo Parlor," *Time*, February 7, 2012. http://healthland.time.com.

WebMD, "Body Piercing Problems—Topic Overview," September 7, 2010. www.webmd.com.

Shantee Woodwards, "Tattoo Shop Tries to Improve Image of Body Art," CBS Baltimore, February 6, 2012. http://baltimore.cbslocal .com.

Websites

Association of Professional Piercers (www.safepiercing.org). The website of the Association of Professional Piercers, an international nonprofit organization, disseminates health and safety information about body piercing to body piercers, health-care professionals, legislators, and the public.

Mayo Clinic (www.mayoclinic.com). The website of the Mayo Clinic disseminates information about the health risks and complications related to body piercings. It also includes aftercare steps and other safety information to minimize these risks.

Tribalectic (http://community.tribalectic.com). The website of Tribalectic, an online community of body piercers, features personal narratives about the experience of body piercing as well as information on related issues such as safety and health concerns.

Index

Bold page numbers indicate illustrations.

Picture Credits

Cover: © Markus Cuff/Corbis, Thinkstock Images

AP Images: 20

Atlantide Phototravel/Corbis: 52

© Chris Hellier/Corbis: 50

© William Fernando Martinez/AP/Corbis: 23

© Roger Ressmeyer/Corbis: 31

© Ingetje Tadros/Aurora Photos/Corbis: 27

Thinkstock Images: 8, 13, 35, 41, 56, 59, 63

Bonnie Szumski has been an editor and author of nonfiction books for more than twenty-five years. Jill Karson has been a writer and editor of nonfiction books for young adults for fifteen years.